WATERVIEWS

FROM WEST MEADOW BEACH TO MT. SINAI HARBOR

FRAN ZAK

The Vineyard Press
Port Jefferson, New York

D1264713

ACKNOWLEDGMENTS

Many thanks to the following people who allowed me to quote from their publications: Wolfgang Wander, Ronald Hull, Robert Valkenburgh, and Robert DeMaria. Also to Steve Fiore-Rosenfeld, Barbara Haegele, John Turner, Eileen Gerle, Nancy Grant and Wendy Fidao. To Ken Brady, Robert Sisler, and Stephen Juliano, who clarified notes on Port Jefferson history. To Doug Reina and Jim Molloy for permission to include their photos. To Marilyn Schulman, Alice Kim, and Pat Belanoff, who offered helpful suggestions and advice. A special thanks to Art Director David Zachary Cohen for his design assistance.

A special thanks to Andrea Prendamano for valuable guidance throughout the book design process.

Finally, with great appreciation to Robert DeMaria, publisher of the Vineyard Press.

CONTENTS

INTRODUCTION

Long Island is one of the most populated seaside areas in the United States and extends from the East River to Montauk Point, a distance of 120 miles. It includes the boroughs of Brooklyn and Queens, with a population of three million, as well as Nassau and Suffolk counties.

The South Shore of Long Island faces the Atlantic Ocean, and is well known for its broad, white beaches. The North Shore has a very different topography. It faces Long Island Sound and is rimmed by a high bluff for most of its length, with many inlets, bays, and harbors.

Recognized as one of the most complex and appealing areas on the North Shore of Suffolk County, the coast from West Meadow Beach to Mt. Sinai Harbor has been protected, and much of it has survived thanks to zoning restrictions, despite the building boom that has taken place in the area in recent years. In earlier days, there was a great deal of fishing in these waters, including whaling from the larger harbors of Stony Brook and Port Jefferson.

West Meadow Beach, on Smithtown Bay, extends from Stony Brook Harbor north to Crane's Neck in Old Field. Nearby is a dream-like place called Flax Pond. Beyond that, we have Conscience Bay, Melville Park, Setauket Harbor, and Poquott. We then arrive at Port Jefferson Harbor, with its long maritime history, many boats and a ferry that crosses the Long Island Sound. Mt. Sinai Harbor, long a favorite fishing port and boating center, and Cedar Beach, with its nature walkways and dramatic views of the bluffs lie to the east.

In my photos, I try to convey the distinctive character and unusual beauty of each location.

WEST MEADOW BEACH

West Meadow Beach might be described as the perfect beach, with an excellent location northwest of the Village of Stony Brook, along Stony Brook Harbor. On this peninsular spit of parkland approximately 1.5 miles long, you can swim in the sight of lifeguards, walk, fish, bird watch, or play beach volleyball. You can play chess or checkers or have your lunch at the stone benches and tables. Families come here to picnic. And on windy days, you can be treated to the sight of windsurfers speeding over the waters as well as exotic kites flying high above the beach.

And so much more...

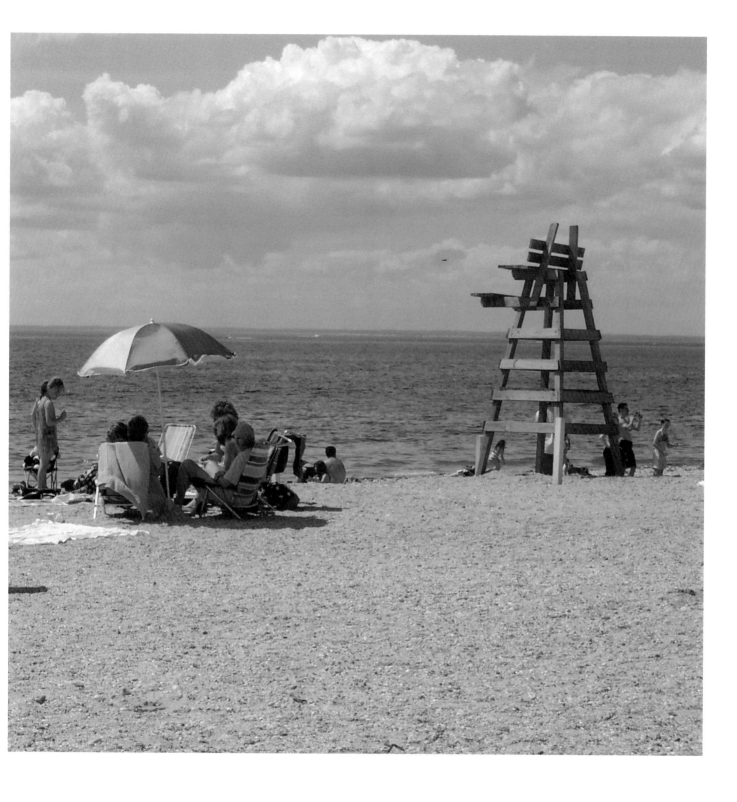

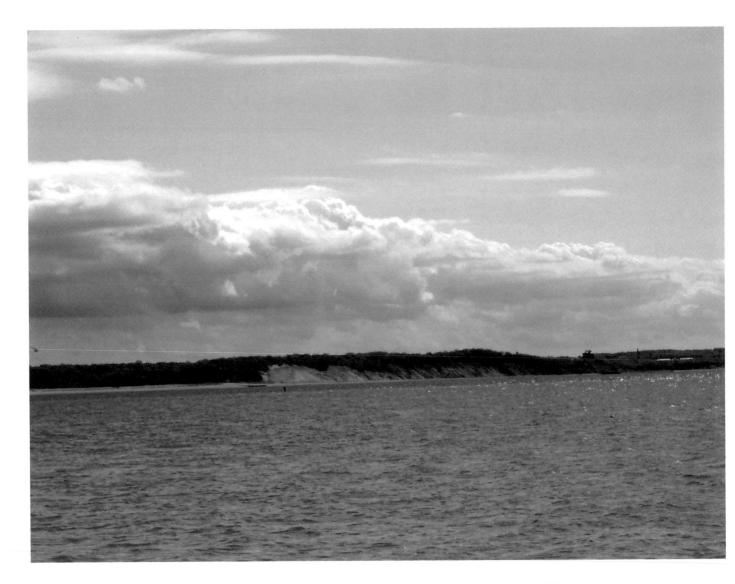

LOOKING WEST TO LONG BEACH

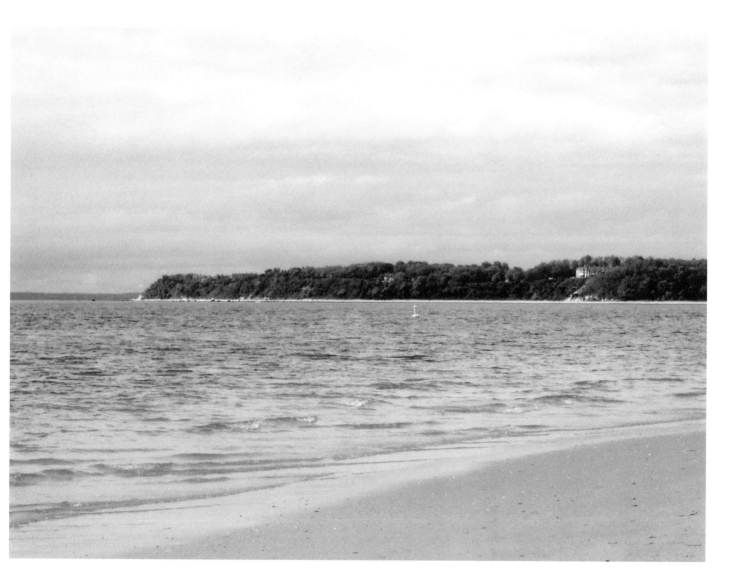

LOOKING EAST TO CRANE'S NECK

Shipman's Cottage, also known as the Gamecock Cottage, was built in the 19th Century on the mainland. It was subsequently moved to the south end of West Meadow Beach, where it attracts a lot of attention because of its solitude and antique construction. William Shipman, a former owner, used it as a boathouse. At some point, it was sold to Jennie Melville, who used it as an aviary. In 2007, it was listed on the National Register of Historic Places. Today, it is the subject of many photographs and paintings.

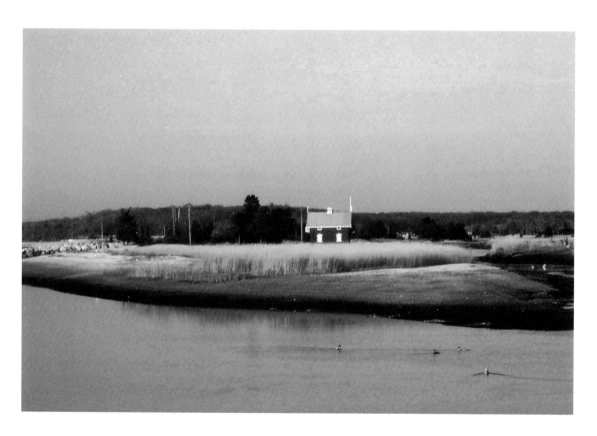

SHIPMAN'S COTTAGE

West Meadow Beach was once the location of a flourishing summer community living in approximately 98 cottages lining the beach, some of them dating back to the early 1900's. Although listed by the National Park Service on the State and National Register of Historic Places, the New York State courts ruled in 1979 that the cottages were built on public land, and the majority of cottages were torn down in 2004 when the leases on the land expired. Only a few of the cottages remain.

COTTAGES AT LOW TIDE

THE LAST OF THE COTTAGES

The natural makeup of the beach consists of areas of sand and pebbles and salt hay. Stones are polished by the years, glisten in the sun, and also make it difficult to walk the beach without rubber shoes like flip-flops or Crocs. Additional sand is brought in annually to repair the erosion that takes place every year.

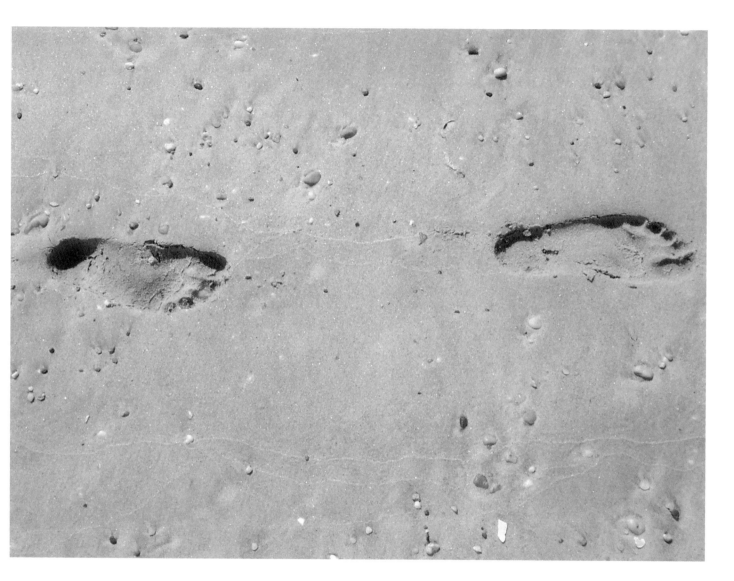

THE SAND AND THE STONES

SALT HAY

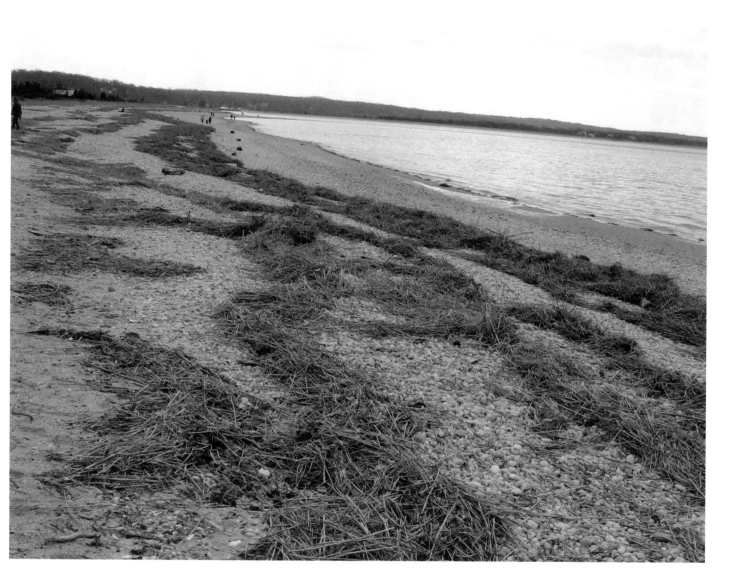

SALT HAY AFTER A STORM

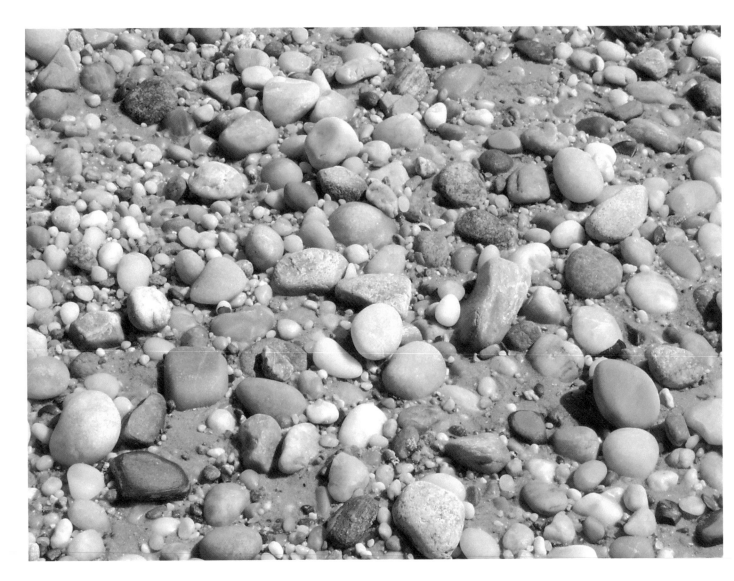

STONY BEACH

MOSSY STONES

HORSESHOE CRAB SANCTUARY
DECLARED AT WEST MEADOW BEACH

"Horseshoe crabs are captivating creatures with pre-historic roots...If we don't protect this species, we will lose one of our most ancient connections to the land and sea."

—Steve Fiore-Rosenfeld
Councilman, Town of Brookhaven, May 6, 2007

"Horseshoe crabs are fascinating animals and an important part of Long Island's natural history... They are an easily observable species at West Meadow Beach, where each year in May and June visitors can watch adult crabs come ashore to mate and lay their eggs."

—John Turner
Director of Department of Environmental Protection
Town of Brookhaven

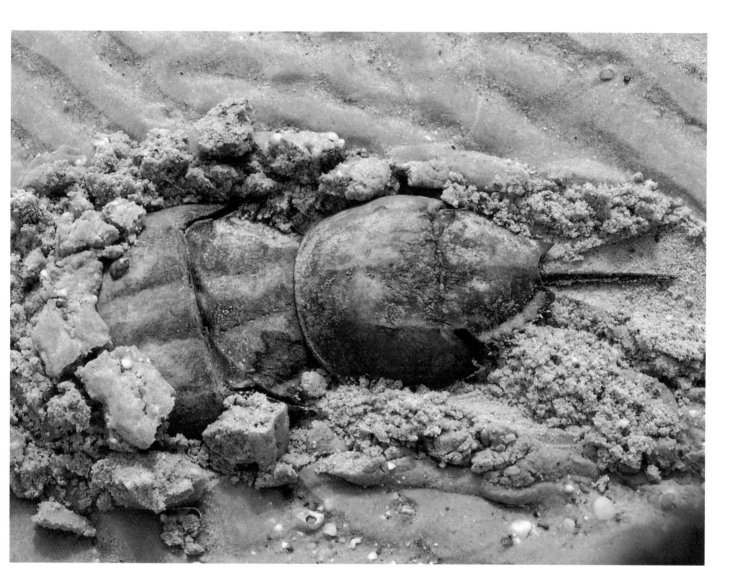

HORSESHOE CRABS AT PLAY

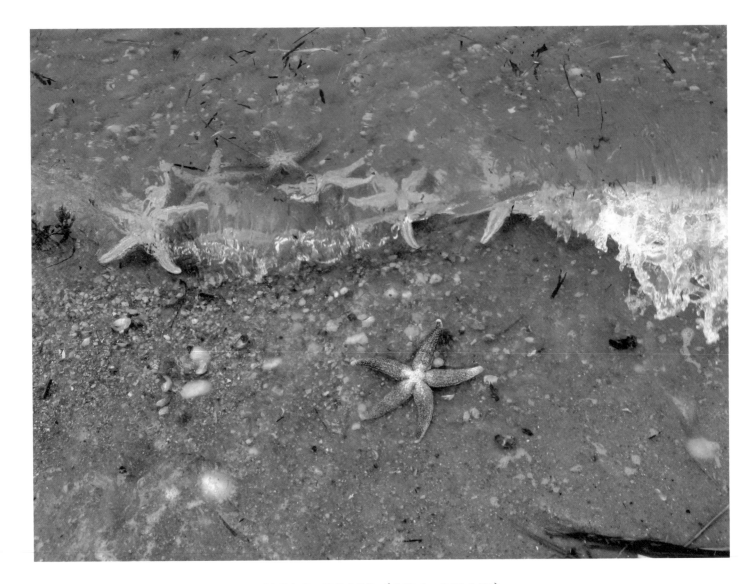

STAR FISH (SEA STAR)

Imagine encountering a colony of starfish on the shore at West Meadow Beach?!
Starfish have long held a special place in the hearts of beachgoers. But did you know that the starfish
is not actually a fish? It's technically an "echinoderm," closely related to sea urchins and sand dollars.
Thus, marine scientists have renamed the starfish a "sea star."

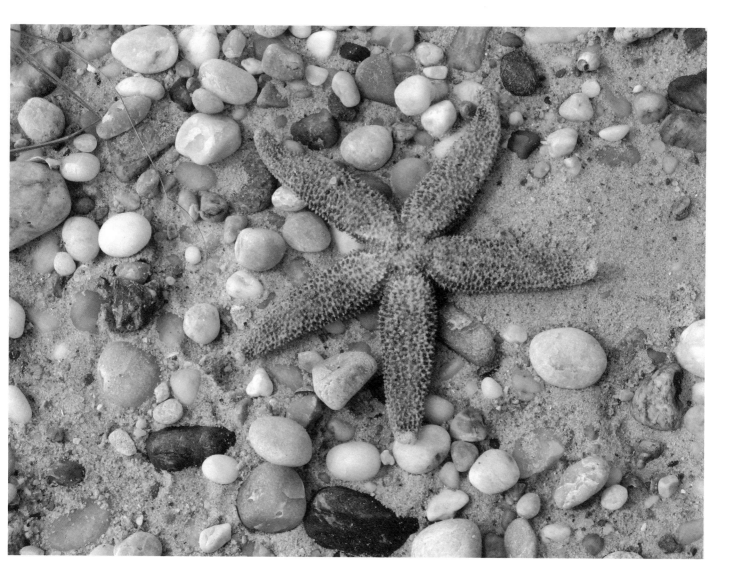

A "STAR" ATTRACTION

You might be surprised to learn that star fish have no brains and no blood.
What we call their "blood" is actually filtered sea water, and their nervous system is spread through their arms.

In the wild, iguanas generally live near water, and are excellent swimmers. If threatened, they can leap from a branch, sometimes from as high as 40 feet (12 meters), and splash into the water, or land safely on the ground. They are herbivores, and feed on leaves, flowers and fruit. Contrary to how they are sometimes portrayed in the movies, iguanas can be tamed, and make gentle, amiable pets, and even companions.

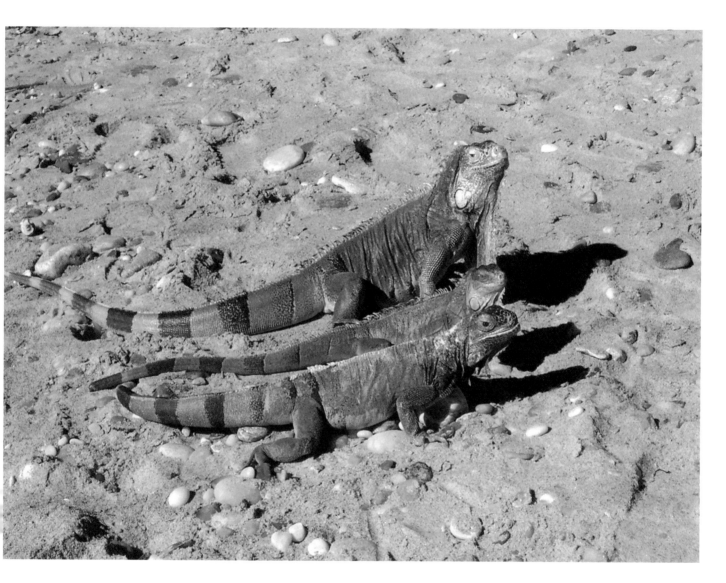

WHICH WAY TO SOUTH BEACH?

"One day we were walking on the beach and met a young woman named Wendy. She told us she frequently came to West Meadow Beach from the South Shore because her three iguanas liked to swim in the Sound. She then proceeded to prove her point by dropping the iguanas, one by one, into the sea where they frolicked around a bit and then swam to shore."

—Fran Zak

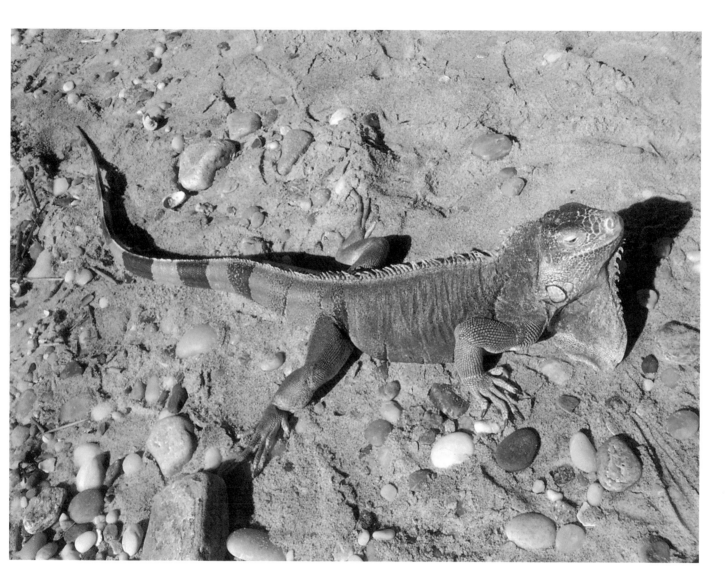

IGUANA BASKING IN THE SUN

"A few minutes from our home this tiny little gem of a beach has recently
been restored to its natural state. It's a bird's (or birder's) paradise..."
—Wolfgang Wander, Stony Brook, NY

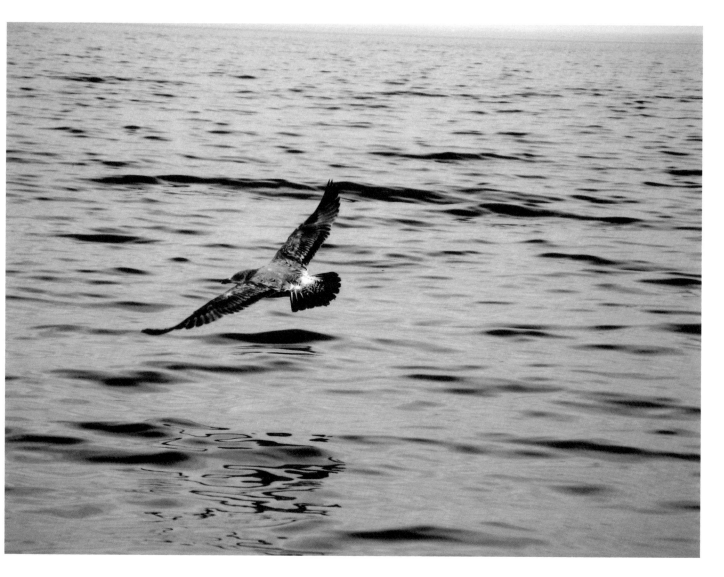

A RARE VISIT FROM A PEREGRINE FALCON

CLOUDS

Here, at the beach, you can sit on a bench and observe a constantly changing world of clouds. The flatness of the terrain and the absence of large trees contributes to a sense of distance and immensity, an endless vista of unending space, as well as the remarkable arc of the sea between Long Beach and Crane's Neck Point.

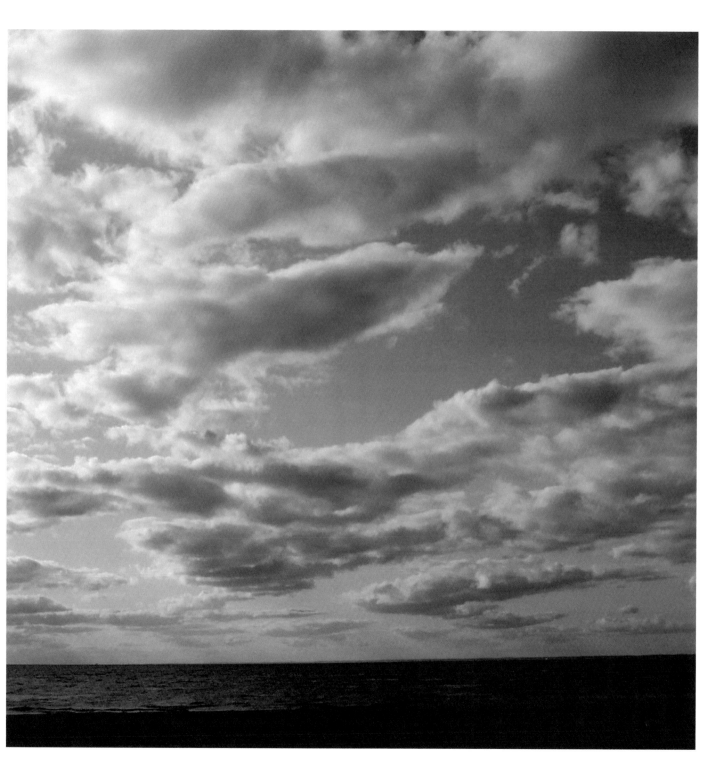

Wind is an invisible force
Made palpable by the visible things
That it moves.

Is it the air itself
Or a force that moves the air?

I have seen the hair of my lover
Swept back on a windy day
As we walk the cold beaches of November.

Have I seen the wind?

—Robert DeMaria
from *Hello Bones and other Poems*

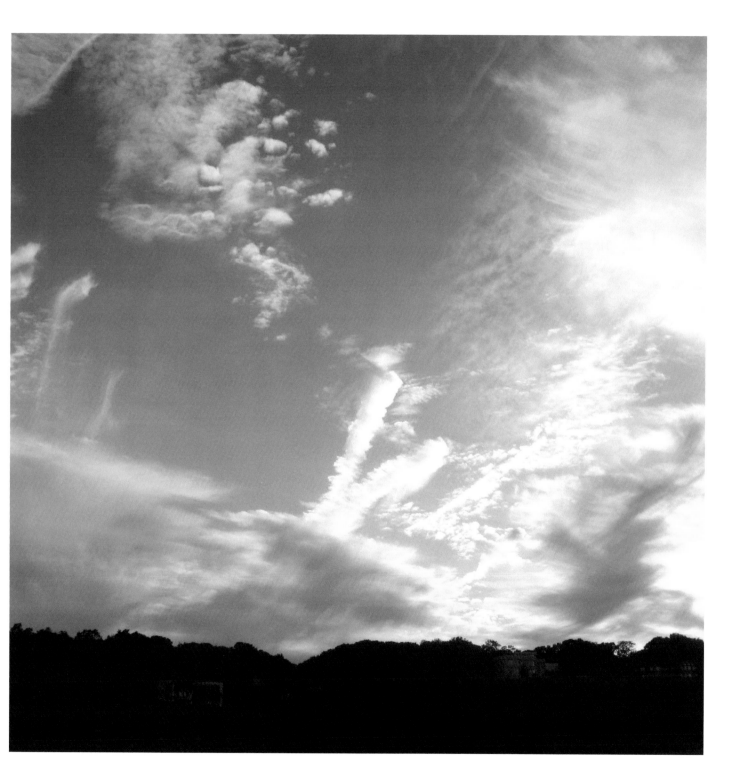

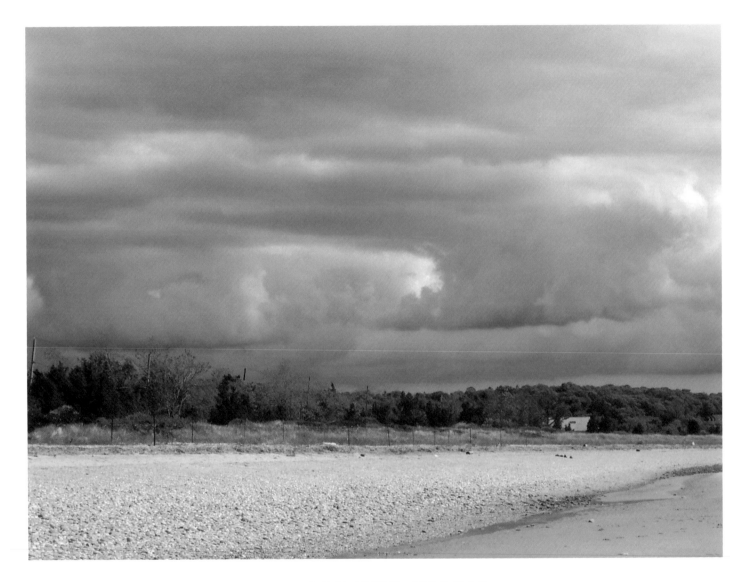

BEFORE THE STORM

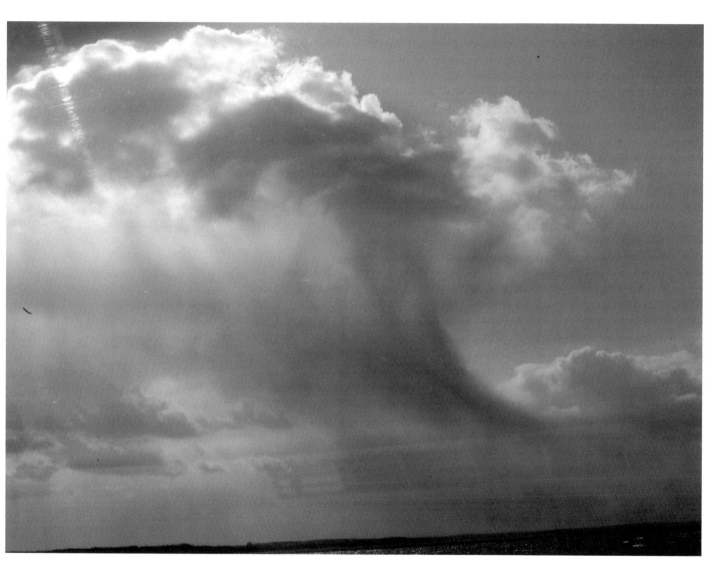

TSUNAMI IN THE SKY

ALL THE PLEASURES OF A SUMMER'S DAY

PLAYING IN THE BREATH
OF THE GODS

Early morning...
In the still hazy sky there is movement, almost ghostlike...
As I come closer, the objects which seem to have a life of their own,
Transform into kites, swaying in the cool breeze.
Form and colour, shaped by man's hand into a vibrant being,
Which draws the eyes to the sky and sets the mind at ease
With the tranquility of the scene...

—Robert Valkenburgh
from *Windgallery Poetry*

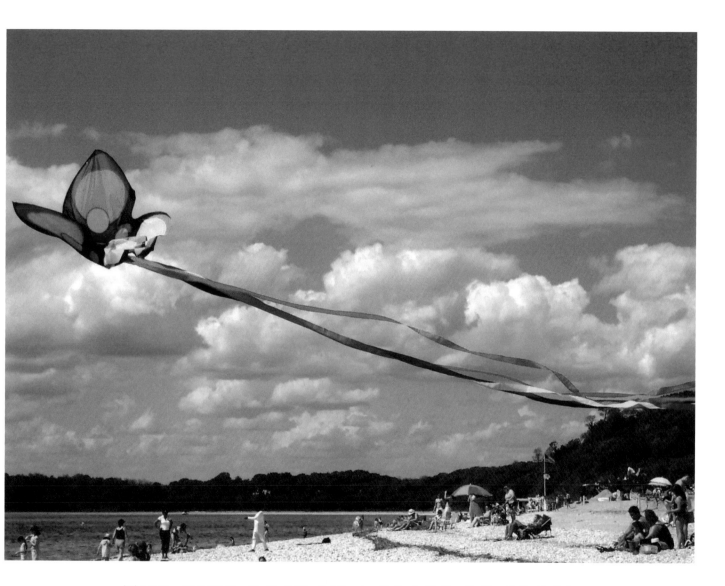

THE KITE ROSE IN A BLAZE OF GLORY

THE TIDES

The tides at West Meadow Beach are more dramatic than they are at most beaches, because of the now famous sandbars that come and go with the rising and retreating of the sea. People often come just to watch the drama of the sandbars emerging , like little islands, and then disappearing again.

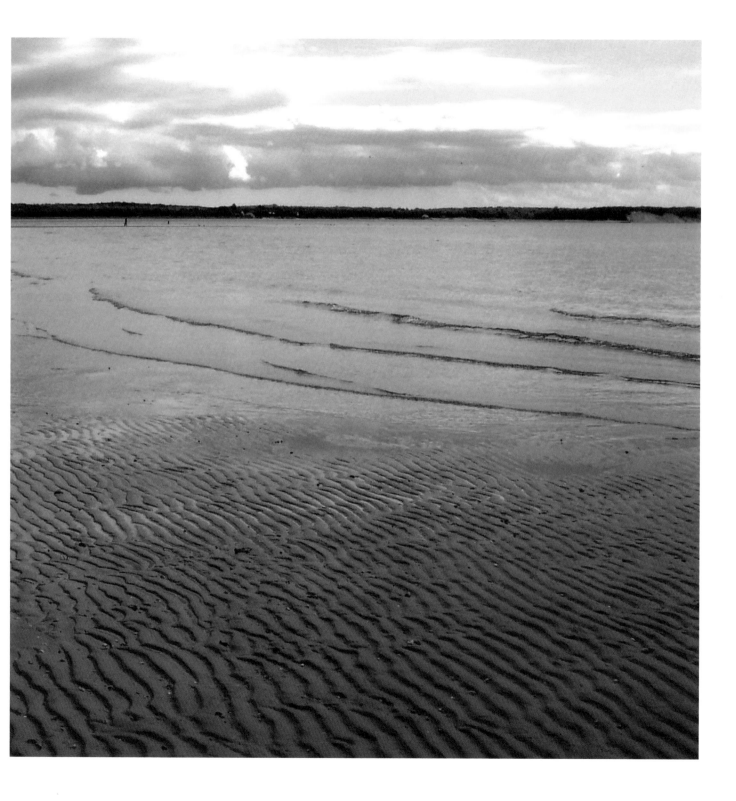

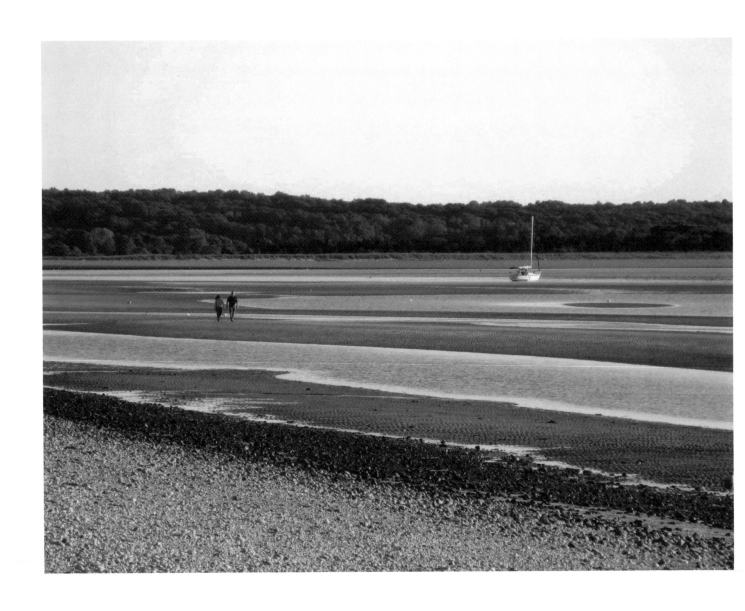

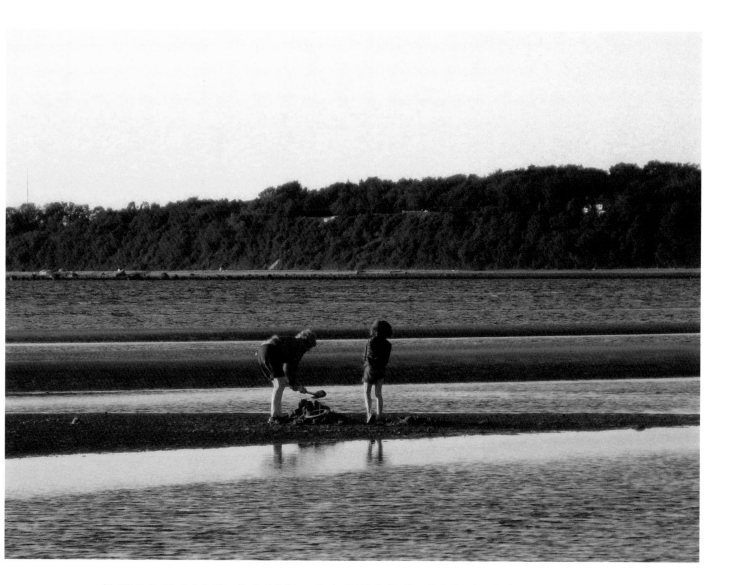

BUILDING SAND CASTLES ON A SANDBAR
WHAT FUN!

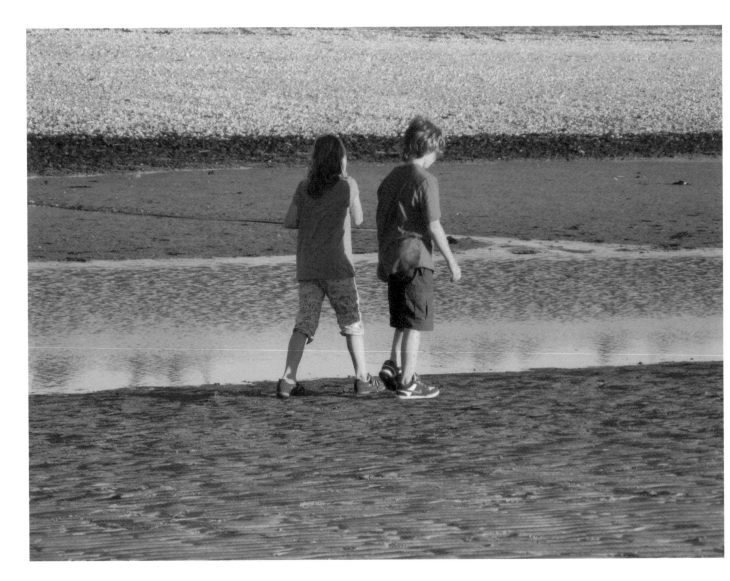

YOUNG PEOPLE EXPLORING THE BEACH

These young people don't want to leave the beach. Who can blame them?
Dusk is a magical time at West Meadow. People often gather at dusk in anticipation
of the dramatic sunsets over the horizon.

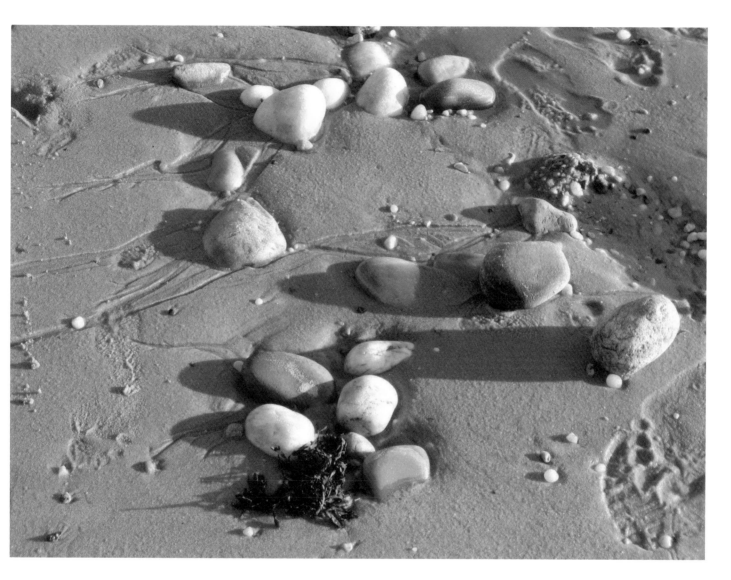

DUSK

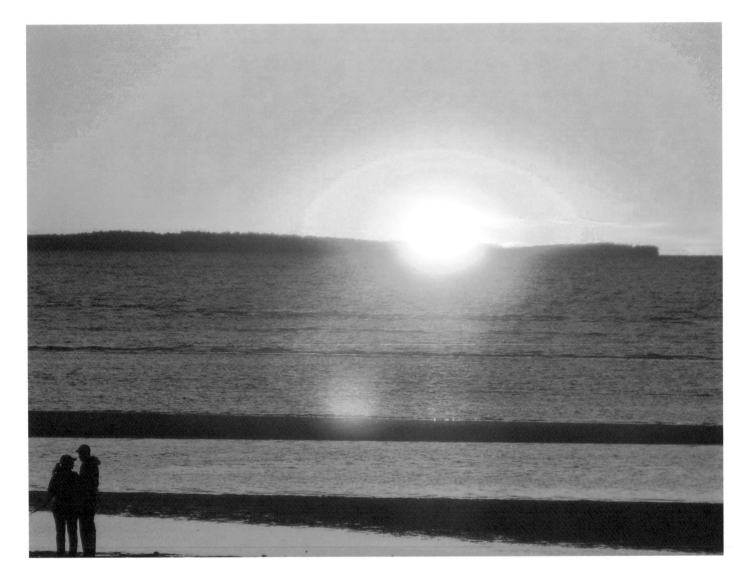

LOVERS AT SUNSET

West Meadow Beach faces the west which means colorful, and sometimes spectacular, sunsets.

FLAX POND

Flax Pond is a tidal estuary consisting of one hundred and thirty-five acres of salt marsh, located behind a barrier beach in Setauket, NY. The pond is home for a large variety of plants and animals which are nourished by the rich nutrients of the wetlands. Flax Pond is a good example of nature's process of renewal.

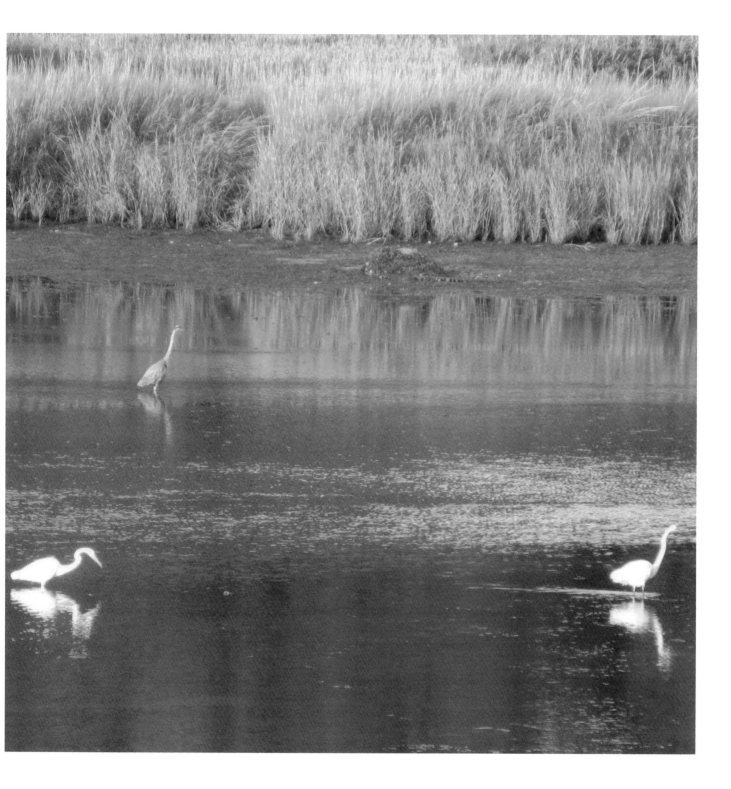

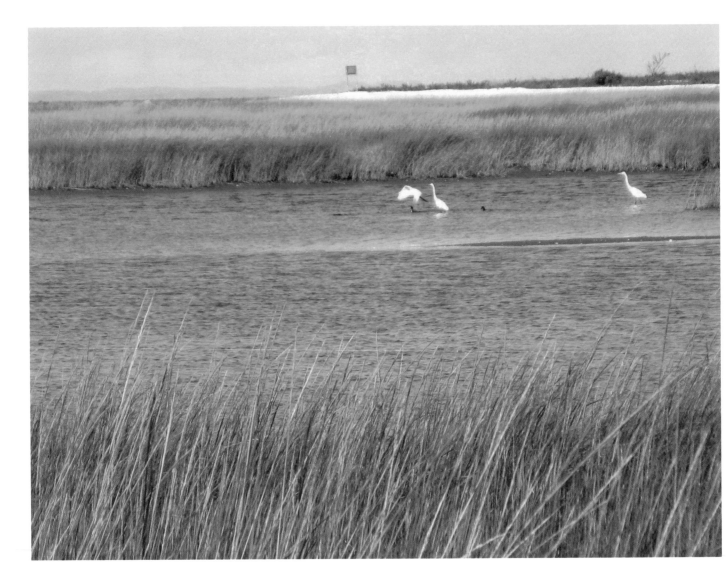

WHAT IS A TIDAL ESTUARY?

A tidal estuary is a semi-enclosed coastal body of water with one or more
rivers or streams flowing into it, and with a free connection to the open sea...

WHAT IS A SALT MARSH?

A salt marsh is a type of marsh dominated by salt-tolerant plants,
such as smooth cordgrass. You can often see wading birds at the marsh.

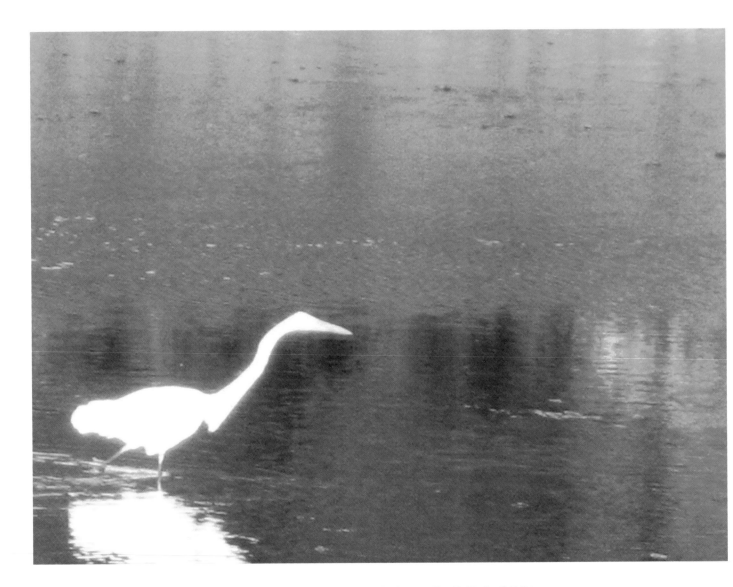

WHAT IS A BARRIER BEACH?

A barrier beach is a single, long, narrow ridge of sand which rises slilghtly above the level of high tide, and lies parallel to the shore.

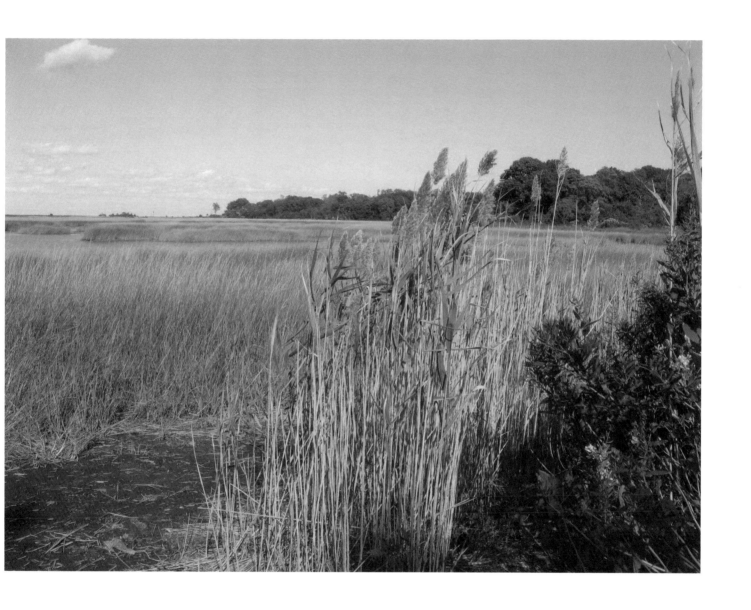

The remoteness of Flax Pond and the almost perfect silence give it a slightly
mysterious feeling. It's a lonely, isolated pond; beautiful and serene.

STONY BROOK HARBOR

Located on Smithtown Bay, Stony Brook Harbor provides another example of a tidal estuary, with six-foot cordgrass, called *Spartina Alterniflora*, flourishing along the entire shoreline. Low tide reveals vast mussel shoals; at high tide, only the upper parts of the cordgrass are visible, and sway with the currents and in the wakes of passing boats.

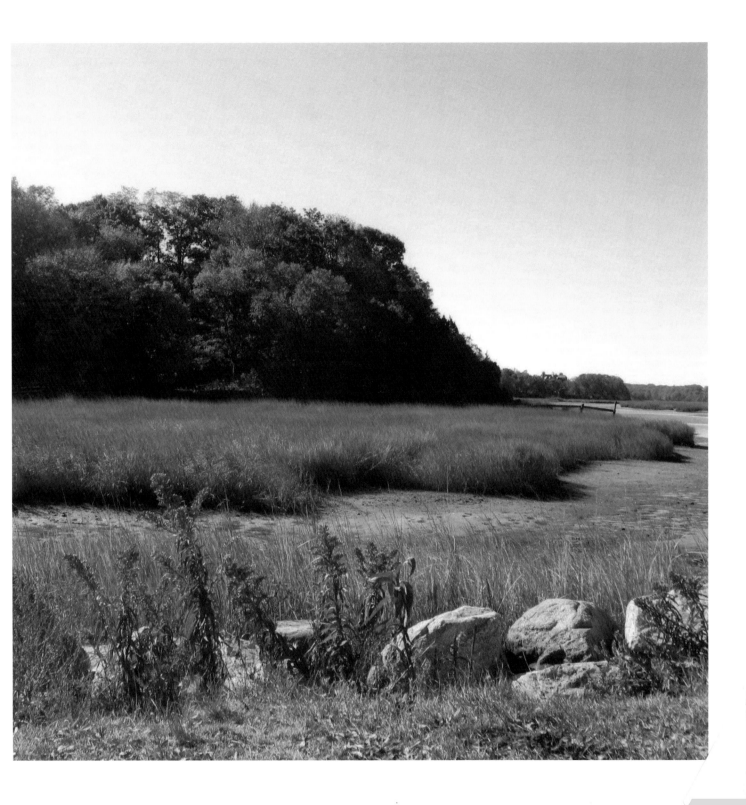

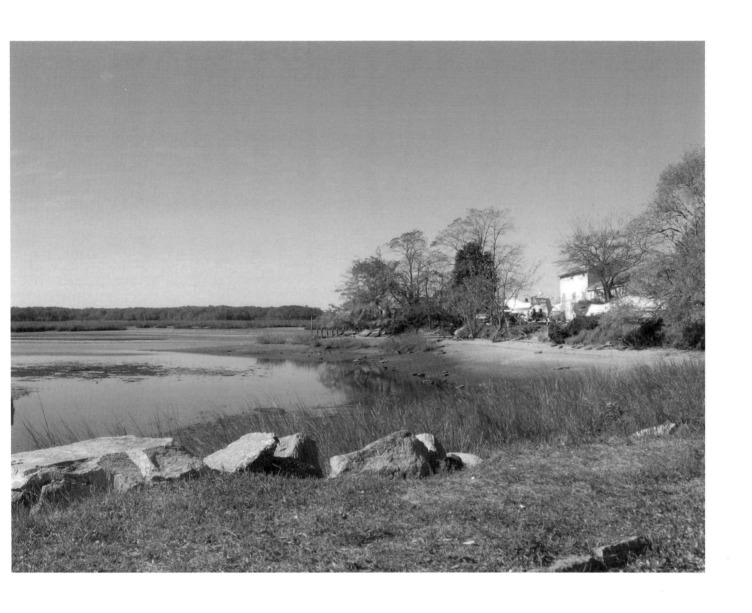

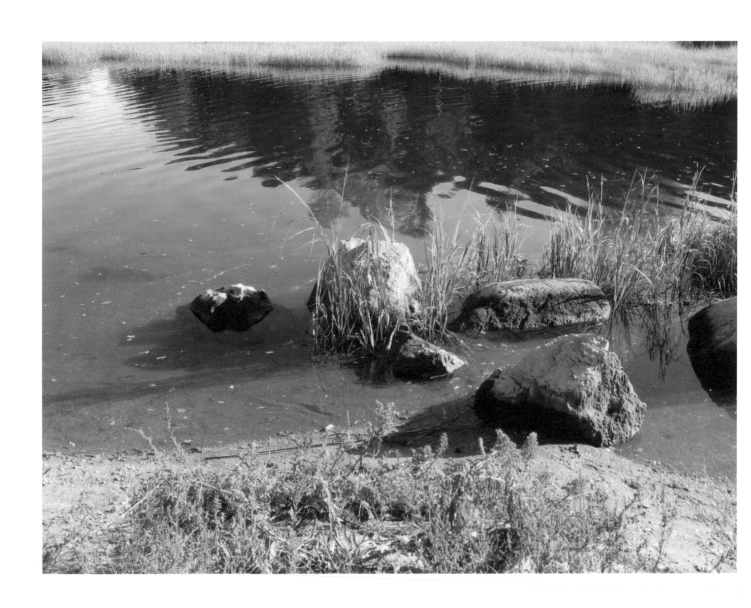

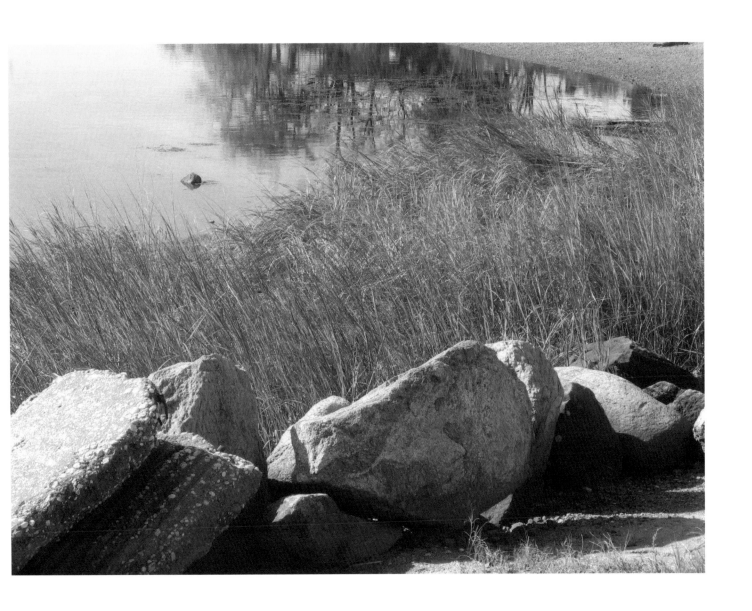

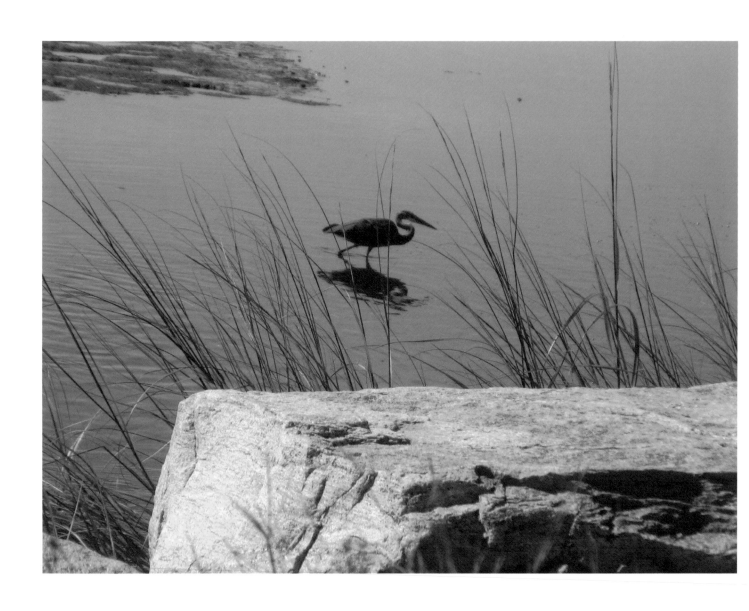

Artists love to paint at Stony Brook Harbor "*en plein air.*"
Ron Hull's poem captures the feeling so well.

The autumn light this time of year,
eclipses summer light by far.

An eerie feeling is in the air,
as we feel what great artist's share.

They go there for the light.
They go there for the color.
They go there for the sight,
of the Sun dancing on the water.

And we come too, to catch the sight,
of dust floating in the light.

Slanting beams through cracks and seams,
lazy days in and out of dreams...

—Ronald W. Hull
Autumn Light

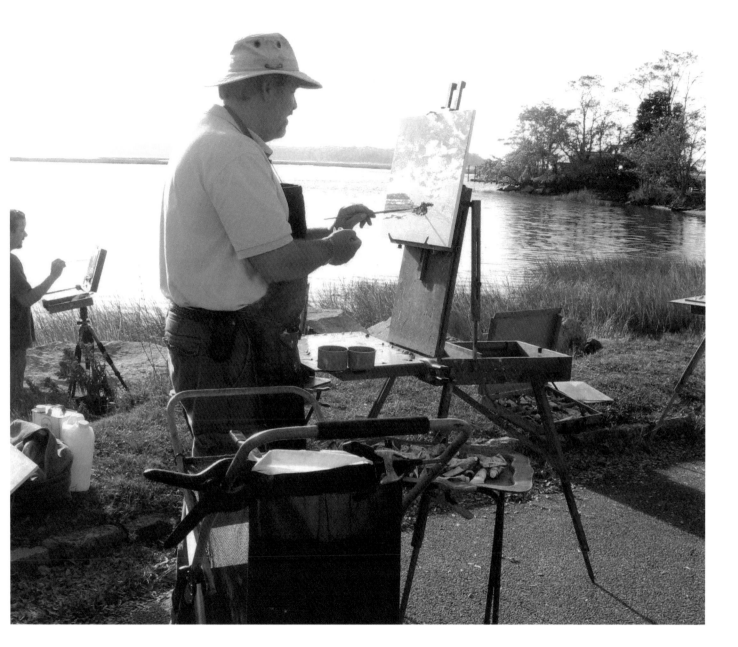

ARTIST DOUG REINA AT WORK

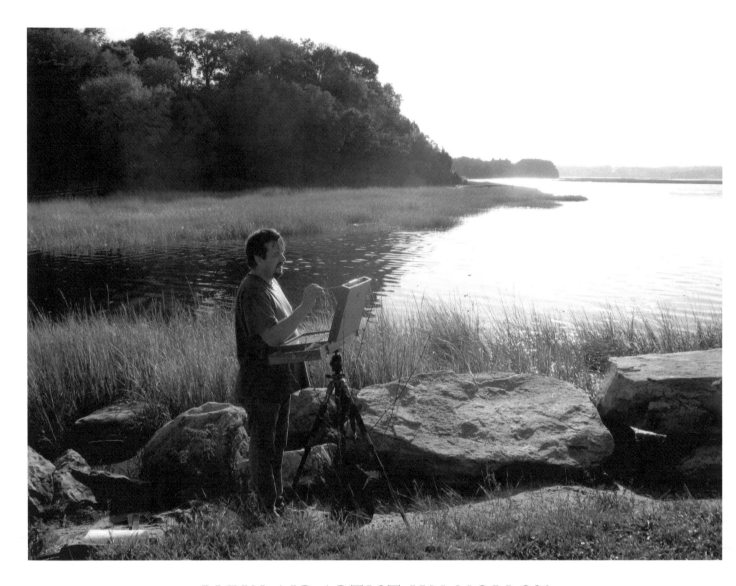

PLEIN AIR ARTIST JIM MOLLOY

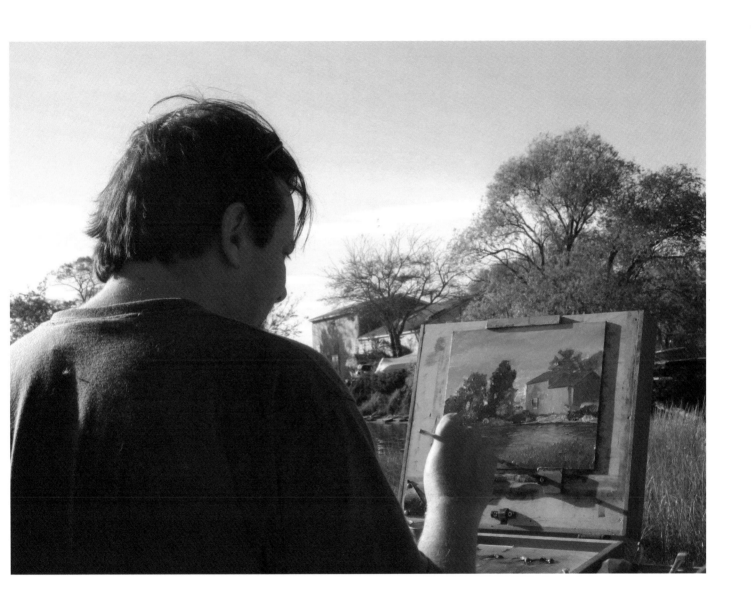

"The artist is a receptacle for emotions that come from all over the place; from the sky, from the earth, from a scrap of paper, from a passing shape, from a spider's web."
—Pablo Picasso

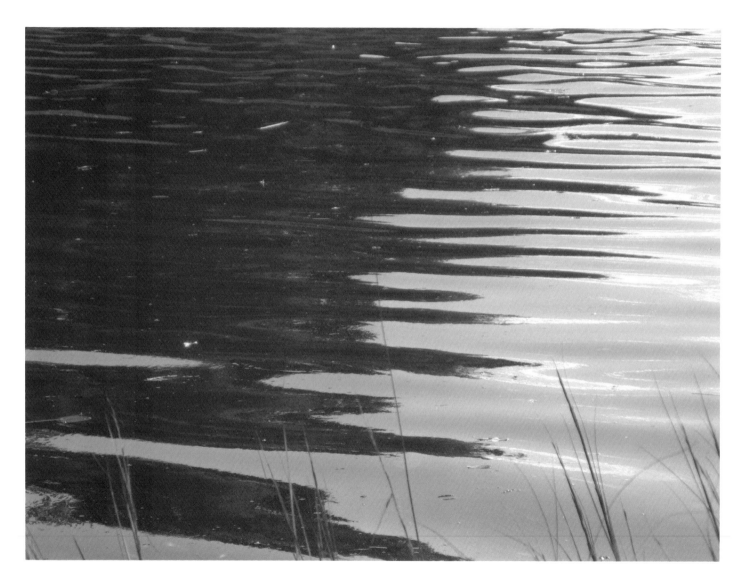

DUSK AT STONY BROOK HARBOR

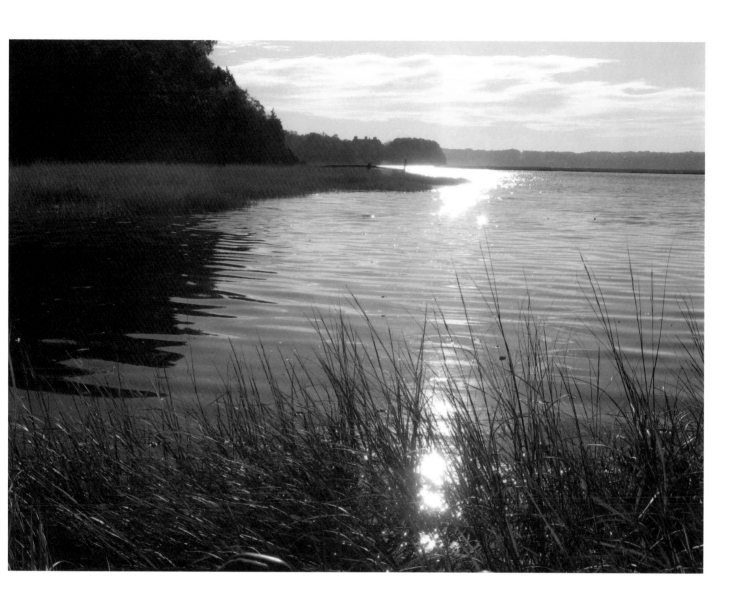

FRANK MELVILLE PARK

The Frank Melville Memorial Park in Setauket opened in 1937, as a memorial to him. It was built by his wife, Jennie MacConnell Melville and their son, Ward Melville. The park's main features are a large fresh water pond, stone bridges, an old mill, and an enclosed arboretum maintained by the Three Village Garden Club. It is a popular place for walking and bird watching, and even for quiet meditation.

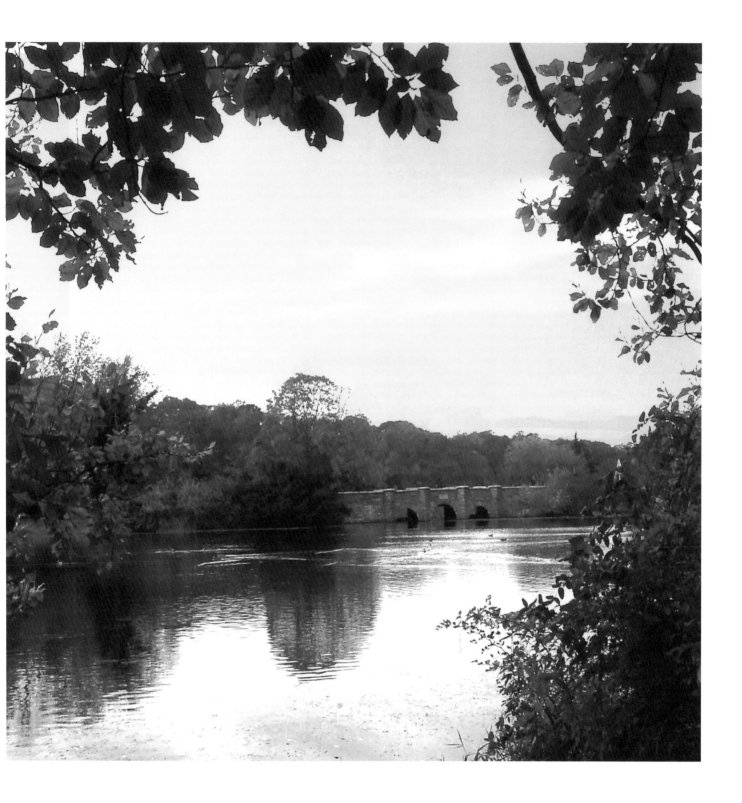

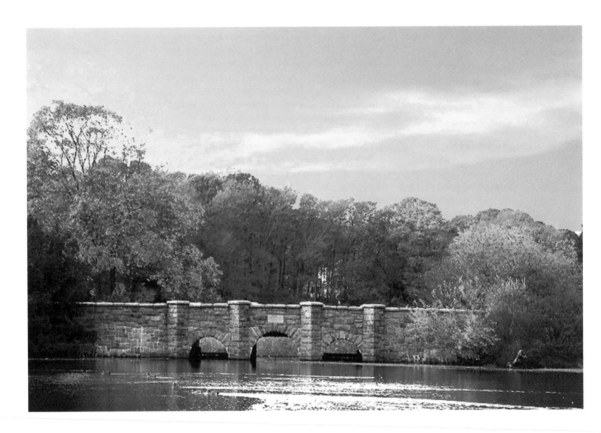

THREE ARCHES

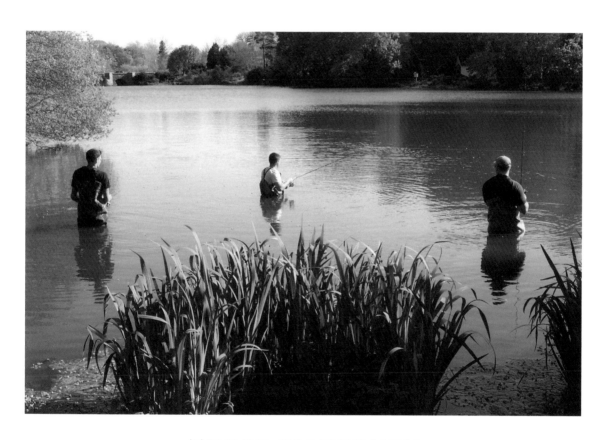

THREE FISHERMEN

Sometimes from the bridge, you can glimpse a large fish called a carp.
Perhaps that's what these fisherman were looking for.

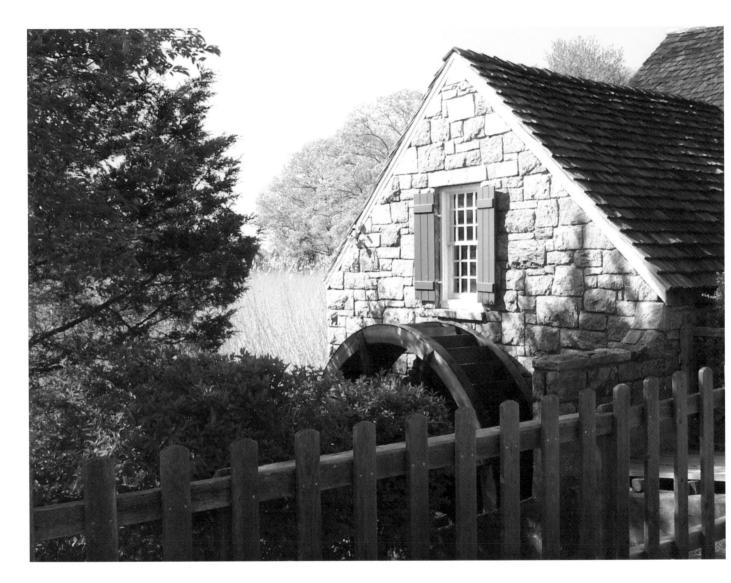

MILL HOUSE

The park is home to a simulated mill house with a working water wheel built the year the park opened, in 1937. The original mill was built on this site in 1664. The wheel is turned by fresh water, which then mixes with the salt water from the marsh on the southern end of Conscience Bay. Ultimately, all the water flows into the Long Island Sound.

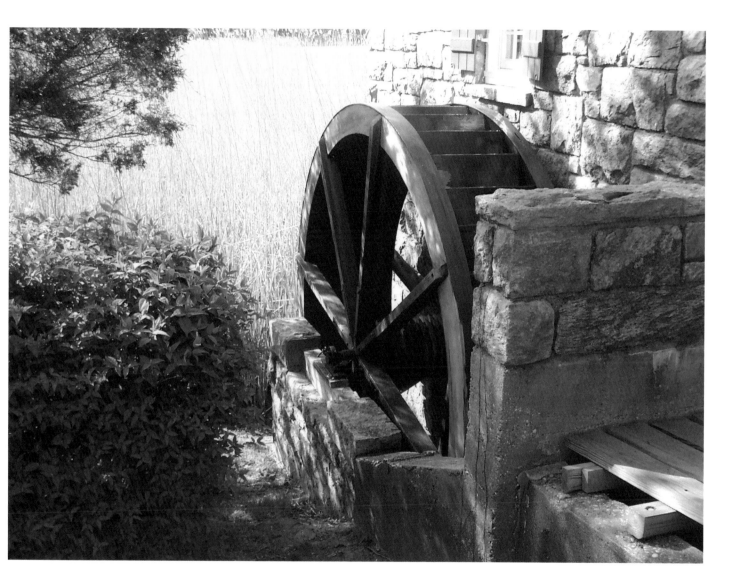

WATER WHEEL

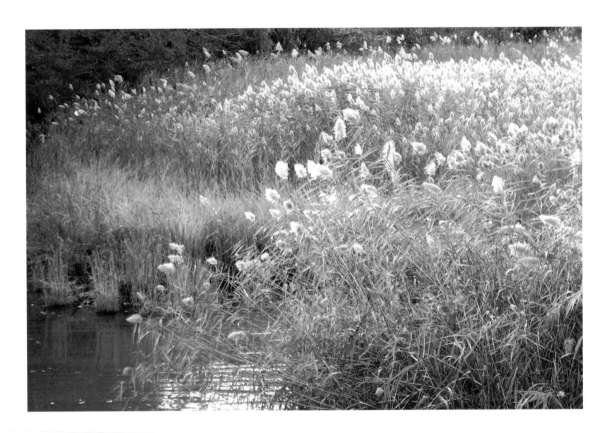

FEATHERY PLANTS

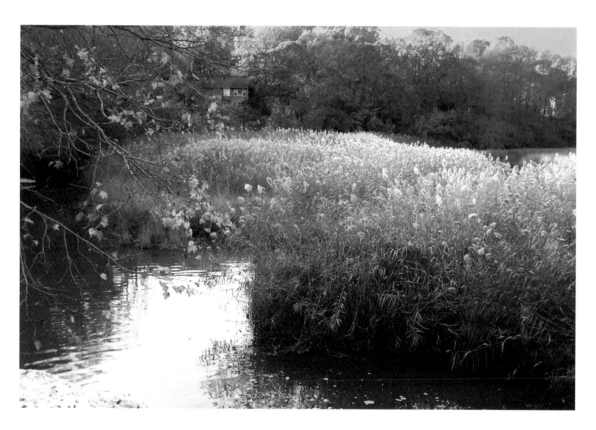

LEAVES AND REEDS

TURNING LEAVES; GREEN WATER

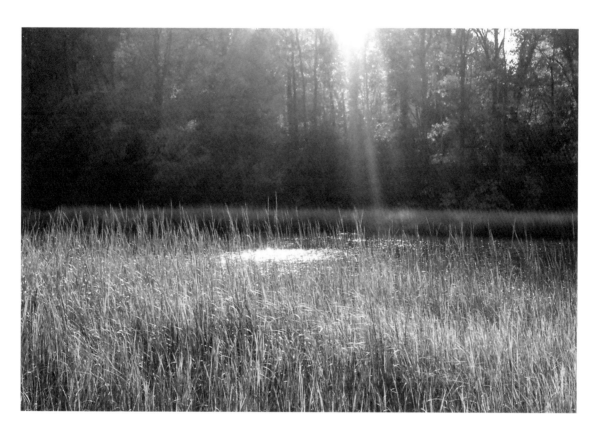

HEAVENLY LIGHT

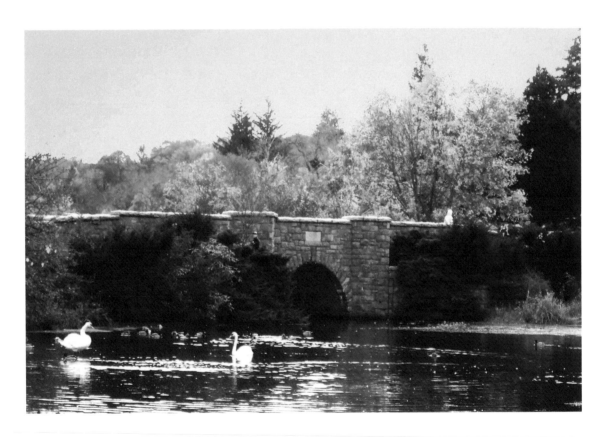

SWANS ON THE POND

Autumn is a magical time at the Park. The trees provide a dazzling display of color,
and the pond is filled with swans as well as migrating geese.

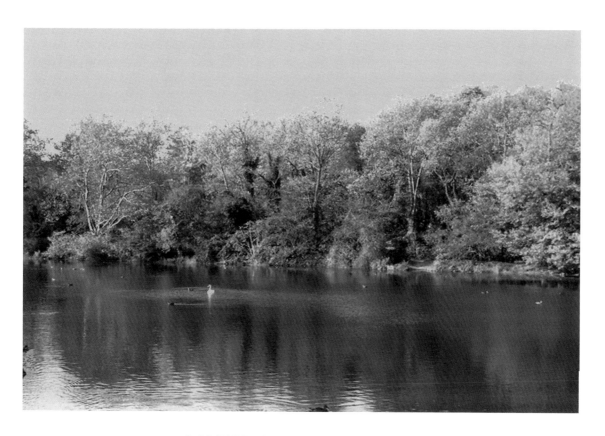

AUTUMN SPLENDOR

SETAUKET HARBOR

Setauket Harbor, along Poquott's Shore Road in the Dyer's Neck Historic District, is a colorful inlet and favorite sanctuary for birds, especially swans.

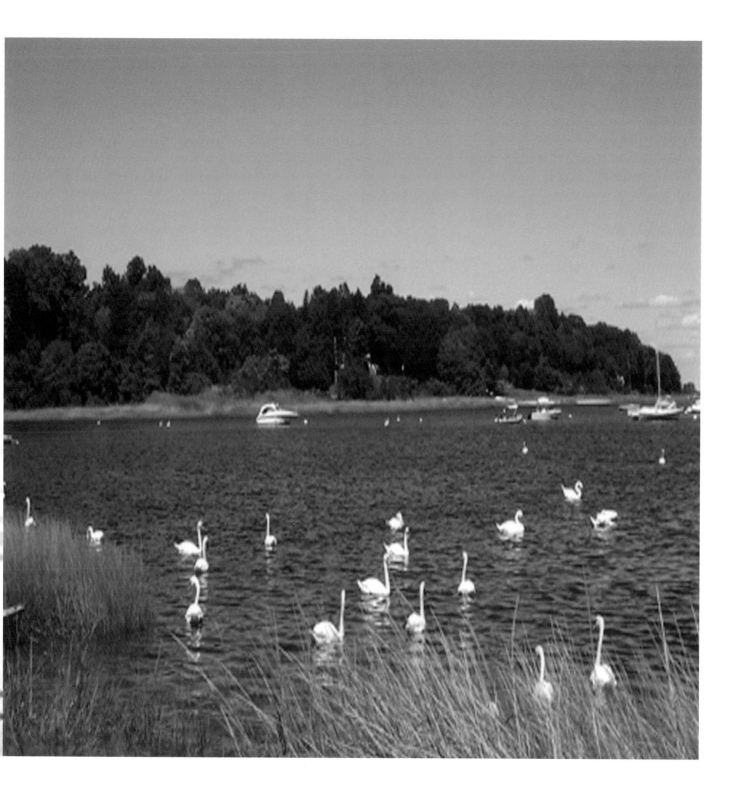

GLISTENING LIGHT

ON GOLDEN POND

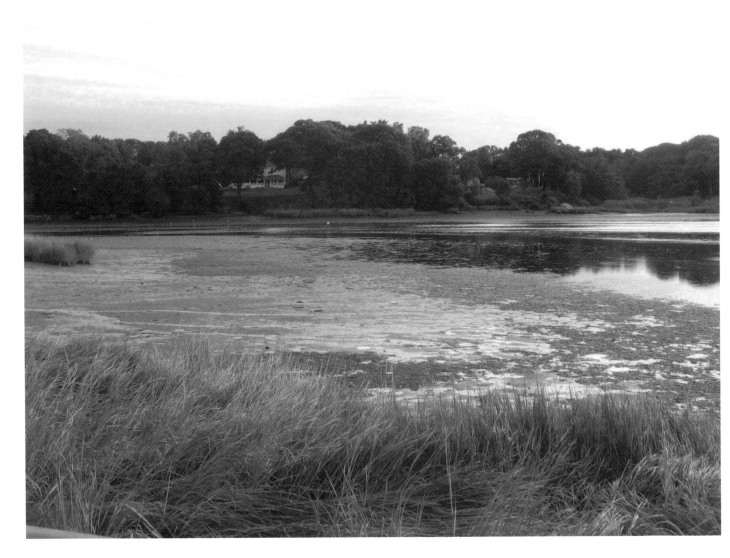

LOW TIDE IN SPRING

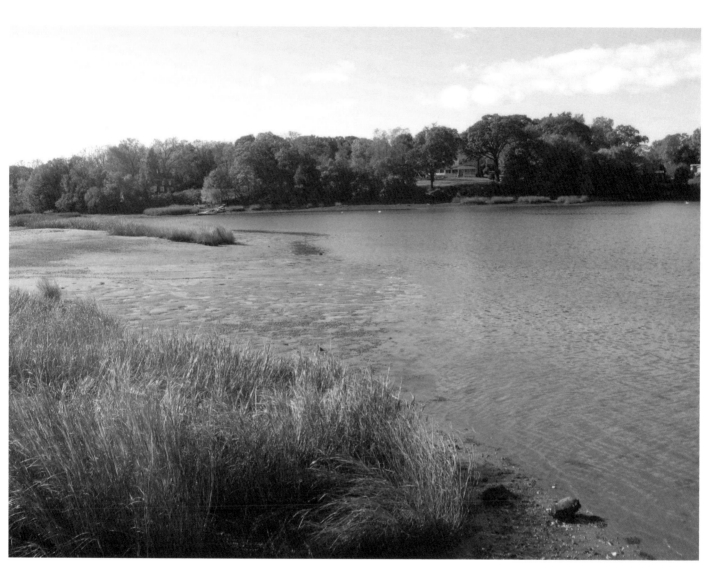

LOW TIDE IN AUTUMN

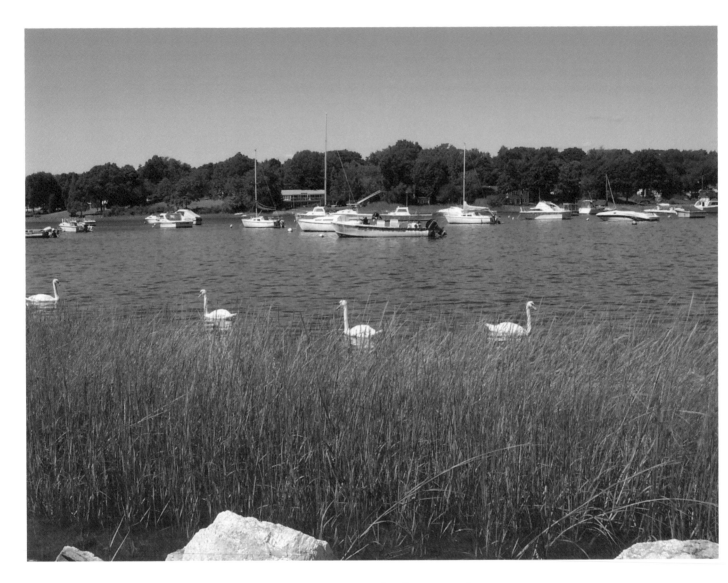

BACHELOR SWANS

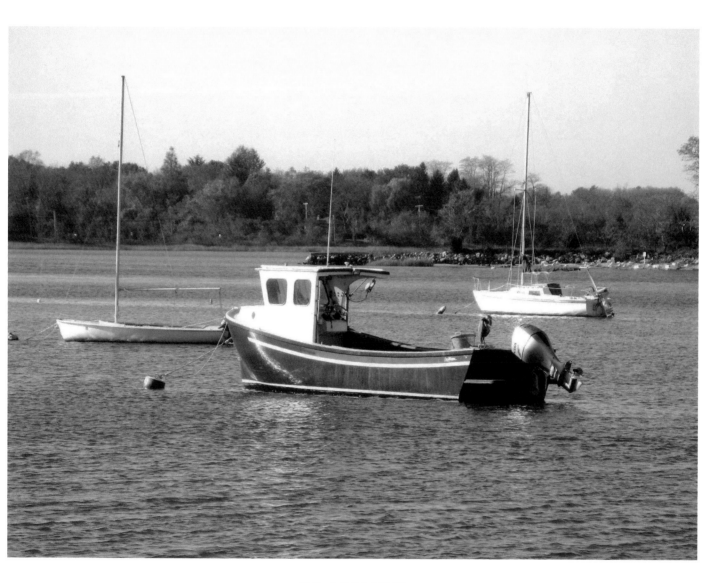

CLAMMER

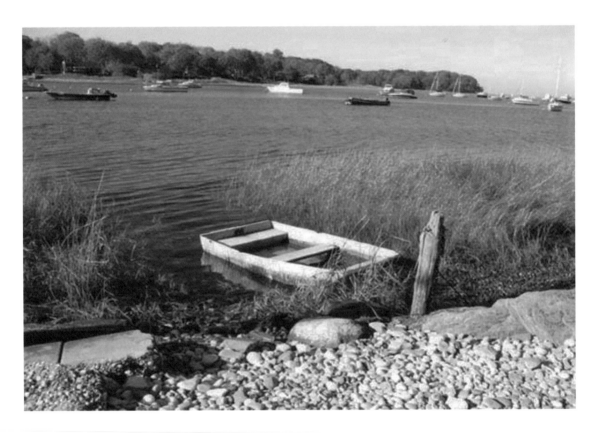

DINGHY IN THE REEDS

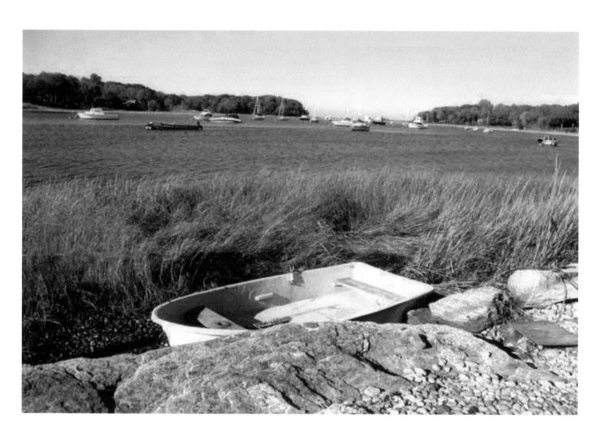

DINGHY ON THE ROCKS

The season creeps to a cold conclusion,
Ice on the river,
Ice in the heart.
The colorless eyes of winter
Stare at the dead earth.
Nothing moves...

—Robert DeMaria
from *Winter Solstice 1989*

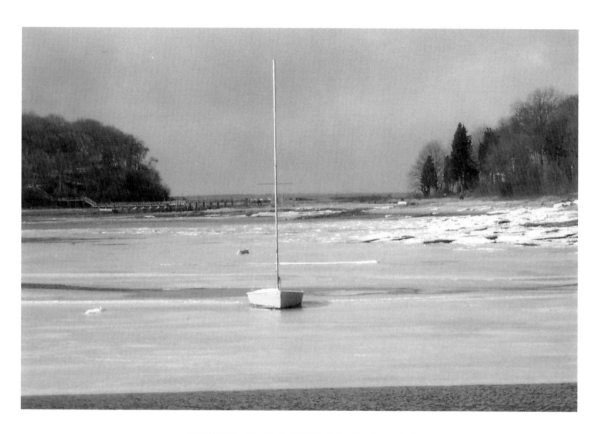

THE LONELY BOAT

PORT JEFFERSON

At one time, Long Island's historic seaport, Port Jefferson, was a small shipbuilding village called Drowned Meadow. The community leaders, realizing this was a poor name for the ship building business, eventually changed its name to Port Jefferson in 1836 in honor of President Thomas Jefferson. The Village was named after Jefferson because he was the major source of funding for a project to prevent the flooding of the lower village, whence the original name—Drowned Meadow.

Stephen Juliano, Port Jeff Village Hall: "Our Village is a visitor's dream, and one of the most picturesque of waterside villages to be found on Long Island. From its beginnings as a waterside home for the Setauket Indians, to its present-day position as a popular day-trip destination, Port Jefferson has grown and prospered..."

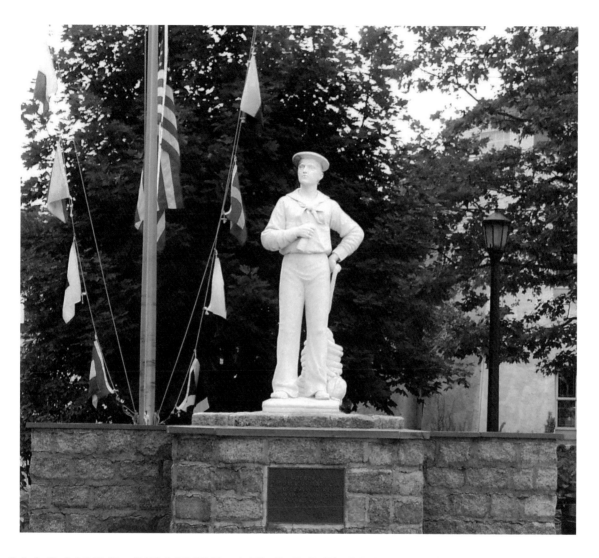

MARINER STATUE AT PORT JEFFERSON HARBOR
REFLECTS ITS SEAFARING PAST

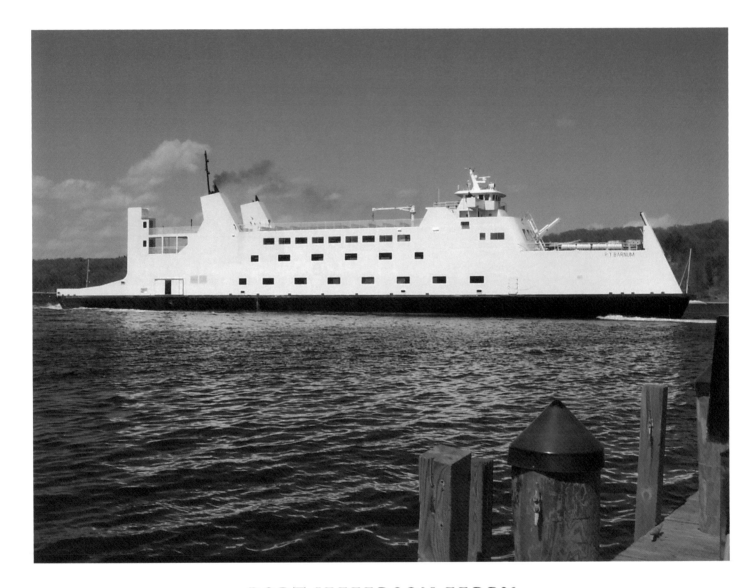

PORT JEFFERSON FERRY

Originally called the Bridgeport-Port Jefferson Steamboat Company, founded in 1883, the Port Jeff ferry continues to transport people and and vehicles across the Long Island Sound between Port Jefferson and Bridgeport, Connecticut.

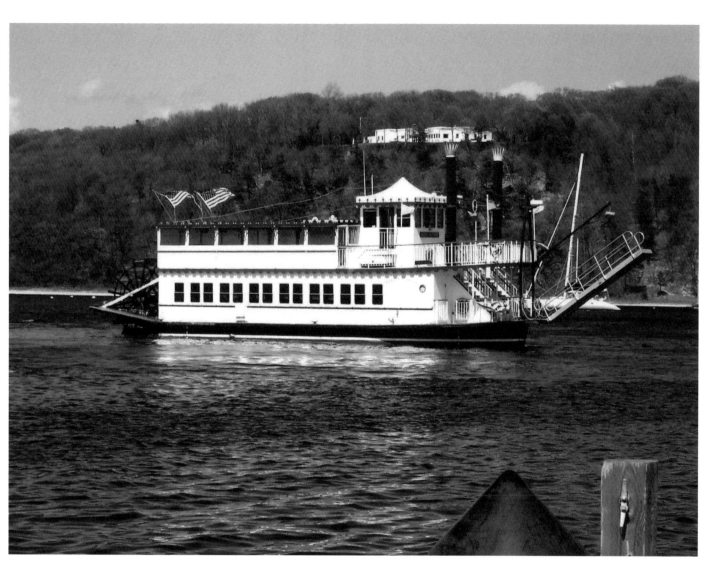

PADDLE BOAT

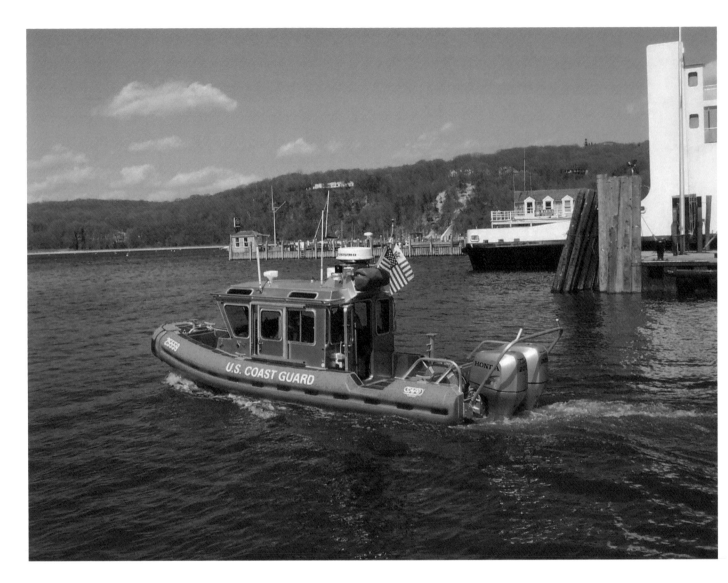

COAST GUARD BOAT

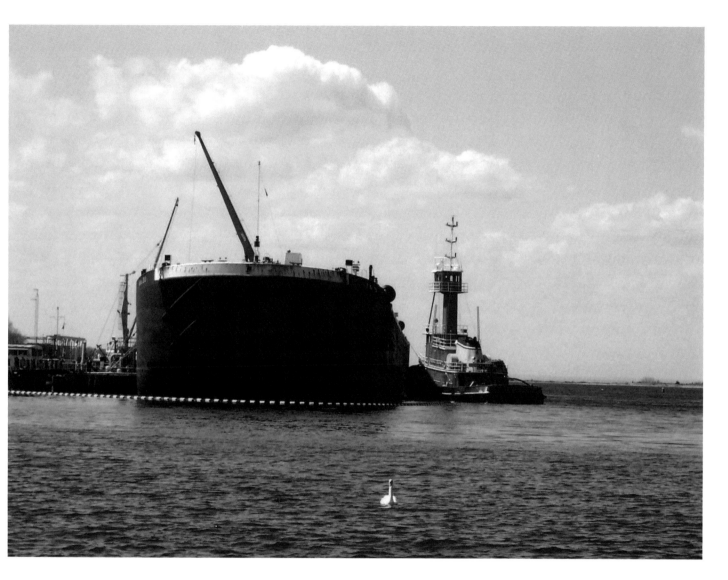

WORKING HARBOR

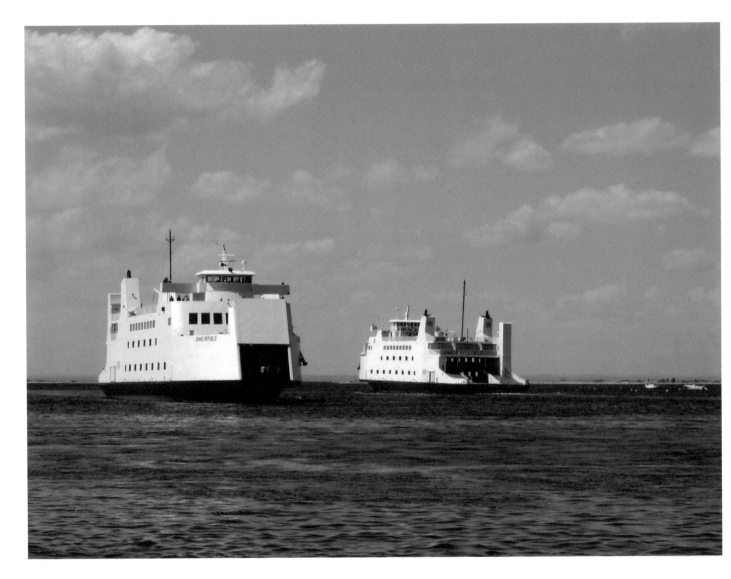

TWIN FERRIES

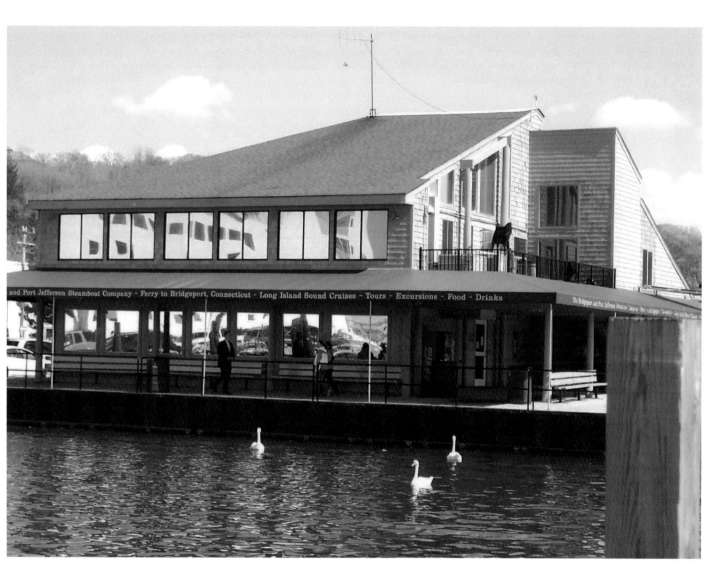

FERRY HOUSE

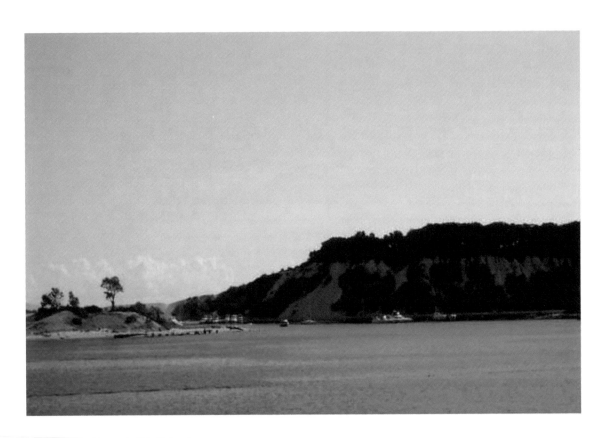

PIRATE'S COVE

Port Jefferson Harbor is one of the only deep water harbors on the North Shore of Long Island. One notable feature is Pirate's Cove. The small cove was dredged in the early 1900's by the Seaboard Dredging Company, artificially creating the sand dunes that are still there.

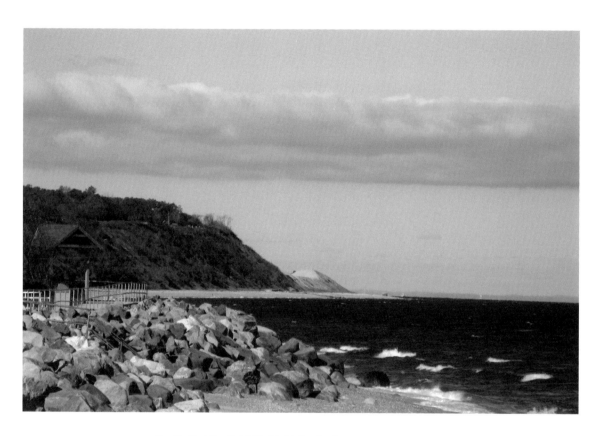

PORT JEFFERSON BEACH

LOOKING EAST TO MT. SINAI
AND CEDAR BEACH

How was Mt. Sinai named? The story is the stuff legends are made of. It is said that Charles Phillips, the first postmaster, chose the name with a Bible and a knitting needle. One day in 1841, or 1842, no one seems quite sure, he sat down, closed his eyes, opened the Bible and pointed the needle. The name closest to the needle would become the name of the area. Mt. Sinai was the closest name, and so it was that Mt. Sinai replaced the existing name, Le Mans.

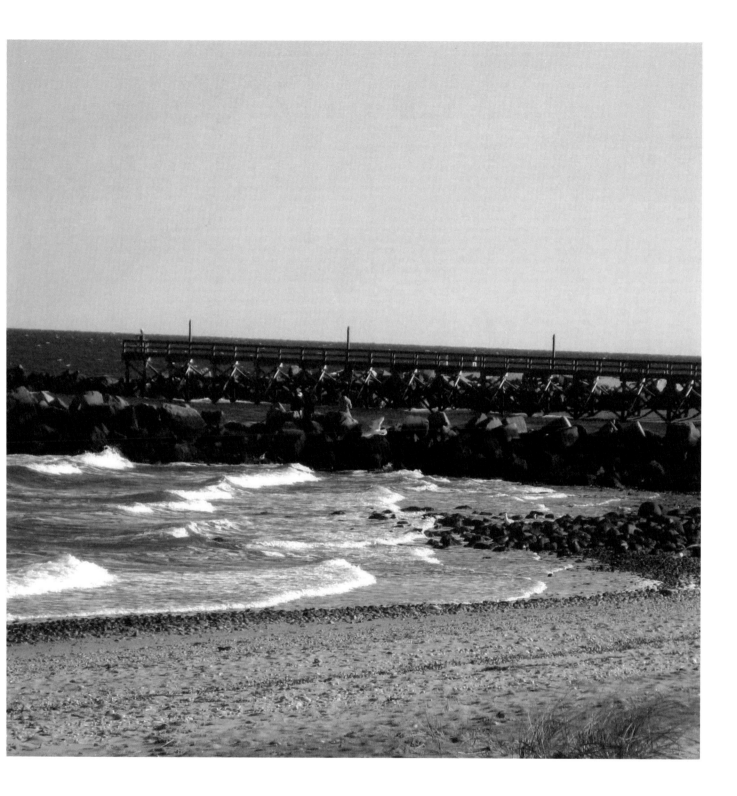

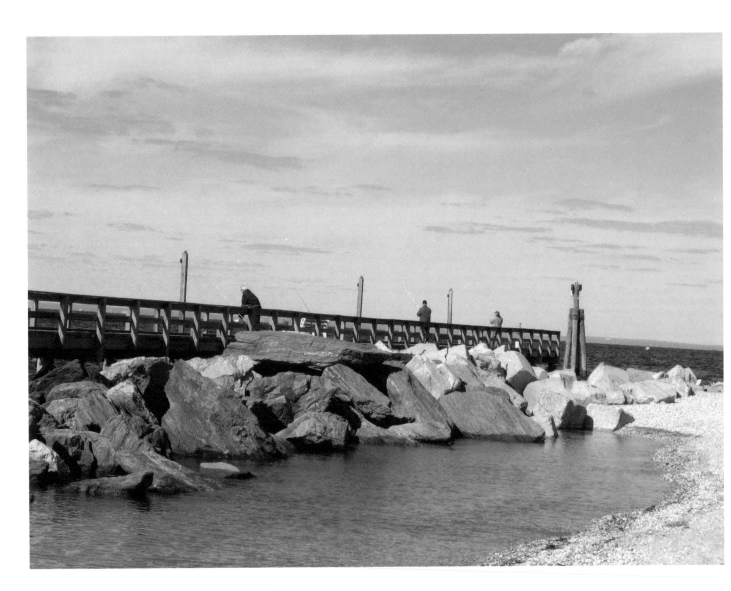

FISHERMAN'S PIER

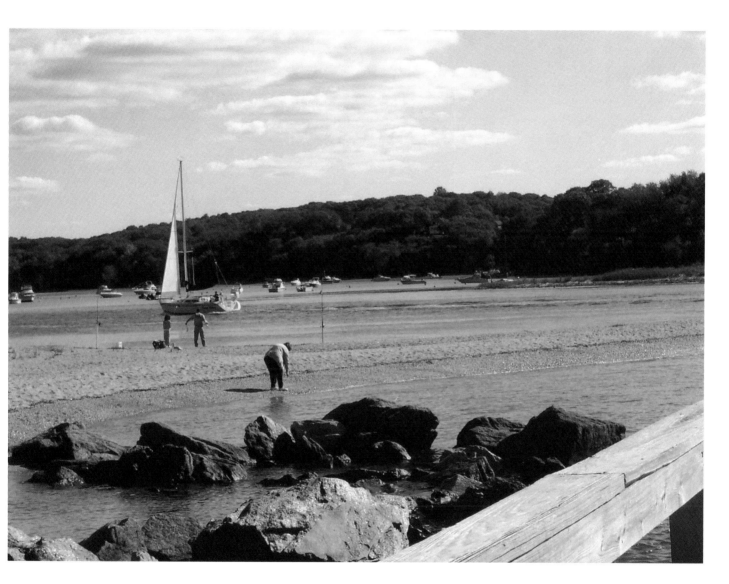

LOOKING FOR SHELLS AT THE INLET

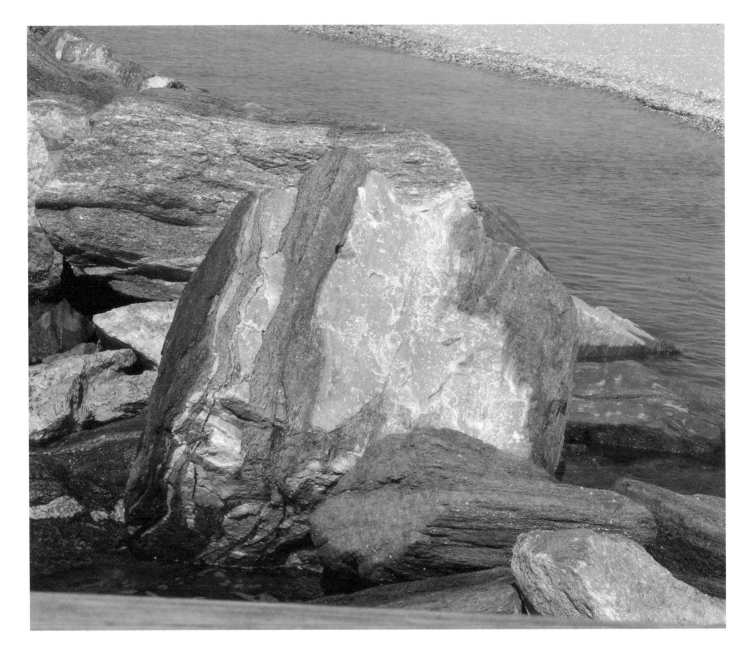

BIG ROCK

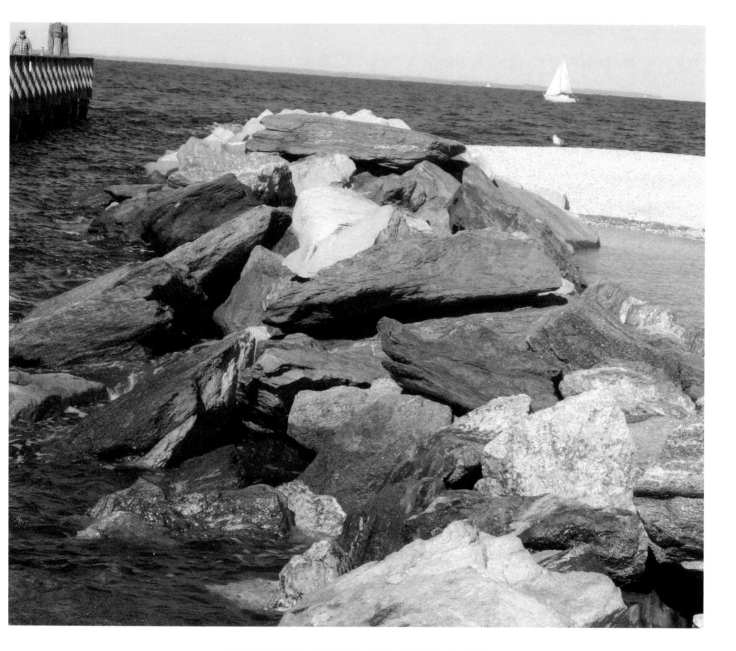

JETTY AND SAILBOAT

Mt. Sinai has been a summer destination dating back to the 1800's, when people from New York and Connecticut came "out to the country" to escape the heat and crowding of the city. What could be better on a hot and hazy day than lounging and picnicking on the beach, fishing for flounder or snapper from the pier, or swimming in the cool waters of the Long Island Sound. People still enjoy those activities, as well as boating, clamming in the harbor and collecting salt hay for garden mulch.

SERENITY AT MT. SINAI HARBOR

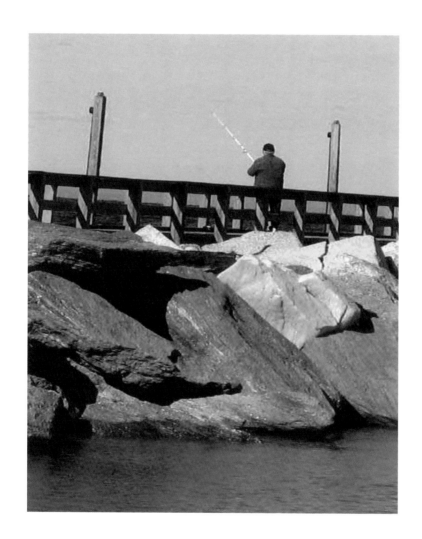

LaVergne, TN USA
06 June 2010
185039LV00001B

AUG 1 9 2010 #24.95

* 9 7 8 1 9 3 0 0 6 7 8 0 6 *